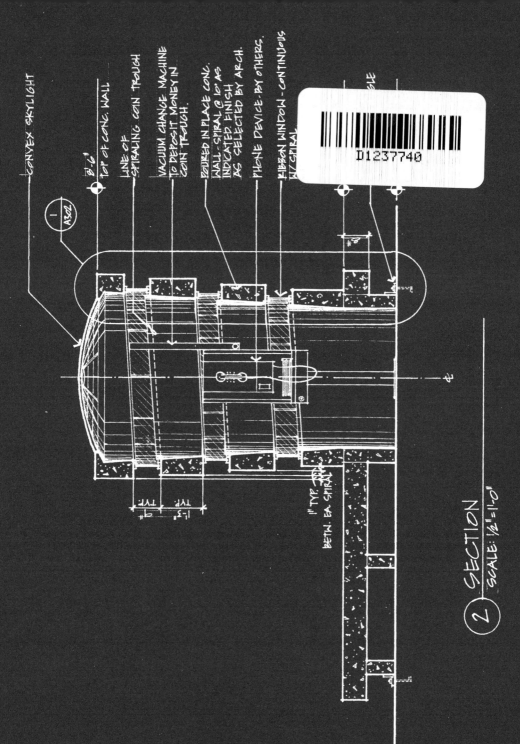

CONVEX SKYLIGHT

8'-6"
TOP OF CONC. WALL

LINE OF
SPIRALING COIN TROUGH

VACUUM CHANGE MACHINE
TO DEPOSIT MONEY IN
COIN TROUGH.

POURED IN PLACE CONC.
WALL-SPIRAL @ 10' AS
INDICATED FINISH
AS SELECTED BY ARCH.

PHONE DEVICE-BY OTHERS.

RIBBON WINDOW - CONTINUOUS
W/ SPIRAL

1
A302

8"
TYP

1'-3"
TYP

1" TYP
BETW. EA. SPIRAL

2 SECTION
SCALE: 1/2" = 1'-0"

PHONE BOOTHS
BY FAMOUS ARCHITECTS

TEXT AND RENDERINGS BY
STEVE SCHAECHER

PREFACE BY CLARE LOOSE BOOTH

Pomegranate

San Francisco

Published by
Pomegranate Communications, Inc.
Box 808022, Petaluma CA 94975
800 227 1428; www.pomegranate.com

Pomegranate Europe Ltd.
Unit 1, Heathcote Business Centre
Hurlbutt Road, Warwick
Warwickshire CV34 6TD, U.K.
[+44] 0 1926 430111

Library of Congress Cataloging-in-Publication Data
Schaecher, Steve, 1967–
 Phone booths by famous architects / text and renderings by Steve Schaecher.
 p. cm.
 Includes bibliographical references.
 ISBN 0-7649-2887-2 (alk. paper)
 1. Telephone booths—Caricatures and cartoons. 2. Imaginary buildings—Caricatures
and cartoons. 3. American wit and humor, Pictorial. I. Title.

NC1429.S356A4 2004
725'.23—dc22 2004045173

Pomegranate Catalog No. A719

Cover and interior design by Mariah Lander

Printed in China

13 12 11 10 09 08 07 06 05 04 10 9 8 7 6 5 4 3 2 1

CONTENTS

PREFACE

THE SILENCE OF THE BOOTHS: WHAT WE ARE LOSING BY USING CELL PHONES

The inspiring edifices showcased in this book are icons of an urban structure—once ubiquitous, if widely diverse in form—that is disappearing fast. The telephone booth has long been the great cultural equalizer, offering anyone with the correct change a cable-borne connection to the wide, wild world. A teenager in Beloit could converse with a chum in St. Petersburg (or Leningrad, as the city was known for most of the phone booth's existence). Professional trombonists could compare the job markets in Prague and Waco. Given a big sack of quarters, any old geezer could find a few minutes' shelter from a Buffalo blizzard and hear what the weather was doing in Maçao. All this and the Yellow Pages too—albeit too frequently suspiciously damp and wrinkled Yellow Pages.

Alas, this benevolent, formerly indispensable devourer of pocket change may soon be only a respected relic, something to be housed in the design collection of the Cooper Hewitt Museum. The cell phone, that tiny, gaudy enabler of public inanity, has driven the phone booth to near-extinction.

Now we must all listen to people talking at the top of their lungs (note to these people: you don't have to speak louder into your cell phone; please stop) as they walk down the street, dine in a restaurant, ride the bus or subway, or give you a medical examination (I'm not making this up: during my last physical, my doctor took a call on her cell phone, spoke to her daughter, and then charged me $300 for the visit). This on top of hav-ing to hear their custom ring tones, whose tinny interpretations of such musical scrap as the theme from *Dr. Zhivago* or *The Way We Were* squeak volumes about the user's taste and intellect.

A case can be made for the preservation of the phone booth not as a quaint object of purely historical interest but as a robust, utilitarian, and (as the booths discussed in this book make clear) beautiful and uplifting device that should still be found on every urban corner. That case is herewith presented in a lengthy but, one hopes, ultimately convincing way. So keep on reading.

1. Phone booths provide room for superheroes to put on their tights and capes. Superheroes (as you know, if you're one) have the remarkable ability to change their clothes without ever getting naked. They go in and come right back out. And no one knows where their other clothes are. But this is why they're superheroes, after all. When the phone booths are gone, the superheroes will go too, and crime—especially bizarre crime—will skyrocket.

2. Phone booths are excellent shelters from rain and snow and wind, even if you have to have to be strong to keep other people from trying to join you inside (unless you are a liberal arts college student; see Point 4). Lean all your weight against the door, flatten your glaring red face against the glass, and emit a threatening growl. This will definitely scare off the interloper. The phone booth is now yours, all yours.

3. They aid in establishing a cover for espionage, e.g., looking like you're talking on the phone when you're really spying on your boyfriend. (Surprise: he's not cheating on you. He really does like to eat pizza four nights a week.)

4. They offer space for multiple liberal arts college students to squeeze in together. Why this attracts them is a behavioral mystery, but they are well known to need the activity, just as pigs need puddles.

5. They can give one hope that one's luck hasn't run out. There may be change waiting in the coin return.

6. They can be sanctuaries in which to seduce an office colleague who heretofore has simply thought of you as a nice girl: you suggest that you both call the office and hear what Mr. Blowart has to say about the current contract, the two of you crowd into the phone booth with the receiver between your left ear and his right ear, or vice versa, and need I say more? No.

7. They can save you from birds gone mad, as demonstrated in Alfred Hitchcock's *The Birds.* Imagine what would have happened to Tippi Hedren had that phone booth not been there for her!

8. They can save you from angry bulls. Tip the phone booth over; lie down behind it. Play dead. The bull will go away.

9. They are places that invite song. Step in, close the door, pick up the receiver, and belt out "Everything's Coming Up Roses" or "The Bear Went Over the Mountain." Passersby may think you're having fun with a loved one on the other end of the line, even if in fact there is no loved one at all, and no one loves you or ever will again.

Assuming that you know people who take you even remotely seriously, get on the phone. Establish a lobbying group. Heckle your city council and local telephone company. Reestablish these urban landmarks. Let a thousand phone booths bloom. Take Back the Booth!

Thank you.

Clare Loose Booth
Chair, Intercity Interdisciplinary Committee
for the Preservation of Outmoded but Nice Things
Secretary, Chickamauga County Singles Club

ABOUT THE AUTHOR

Born in 1967 in Columbus, Indiana, Steve Schaecher is a practicing architect as well as a cartoonist. This is the third book in his inspirational . . . *by Famous Architects* line. He enjoys trying to be funny and entertaining while educating the public about architecture, creating his own warped views of the design approaches certain architects may have taken to such obscure structures as telephone booths, outhouses, mobile homes, and so on.

Schaecher lives in Indianapolis with his wife, Susie, and children, Nathan and Lindsey. He can be reached through his website: www.dipahead.com.

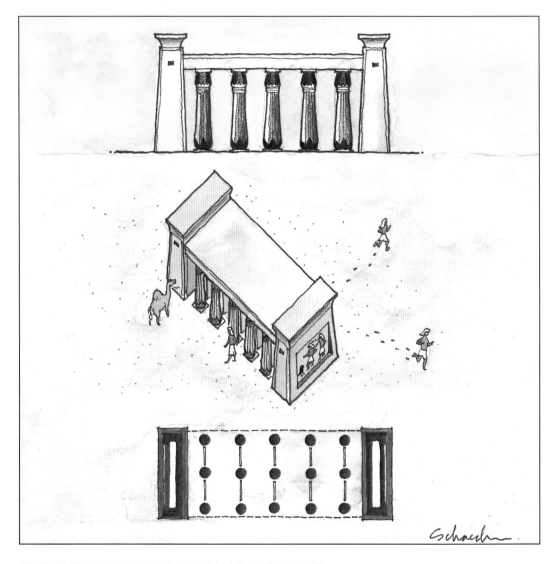

HYPOSTYLE EVERY-FIVE-MILE STALLS

THE EGYPTIANS

c. 3200 B.C.–1085 B.C.

Ancient Egypt has fascinated archaeologists for as long as the discipline has existed. Egyptian life revolved around its vast surroundings. The Nile River's annual flood provided a fertile soil that nurtured the area. The surrounding mountains, sea, and desert protected the Nile Valley from invasion. A stable political and religious culture developed, allowing Egypt a unique degree of stability for more than 2,000 years, with commensurate development of magnificent art and architecture.

The Nile Valley stretched for more than 900 miles. Adobe homes were nestled in the valley and in the countryside. Trade and communication were essential to the survival of Egyptian society.

Hieroglyphic tomb paintings have revealed that, to facilitate communication, the Egyptian royalty constructed a series of halls around the valley. These hypostyle halls (rooms carried by many supports) worked similarly to the way the modern phone booth works. Slave couriers brought each message from one hall to the next until it reached its destination. Pharaohs could converse with anyone in the kingdom using this network. Who was being mummified, who was the latest to part the Red Sea, and how many common folk were crushed while building my pyramid today were daily topics of conversation between the living gods over their "throne" lines.

PHONE BOOTHS
BY FAMOUS ARCHITECTS

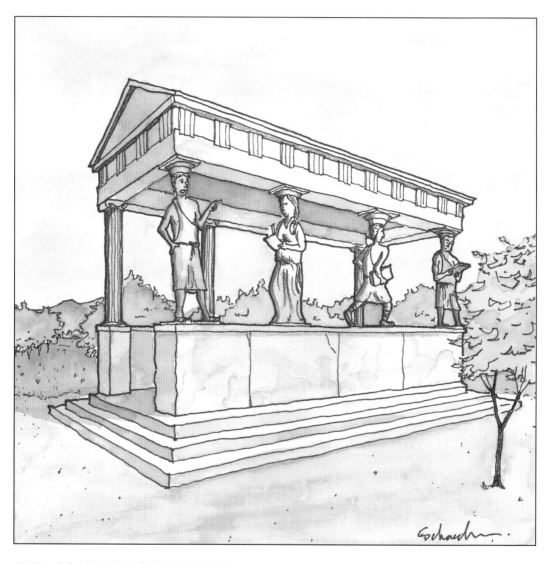

THE COMMUNICATHENEUM

THE GREEKS

c. 800–400 B.C.

The foundation for much of Western society originated with ancient Greek civilization. Greek culture was rich with philosophy, science, history, democracy, and the arts. Man's place in nature was interpreted variously; he could create his own destiny and express his intellect. The diversity of individuals and the self-sufficient communities that constituted Greece contributed to its varied culture.

Architecture was a stately expression of Greek high culture. The Greeks established the classical orders—Doric, Ionic, and Corinthian—with uniform proportions and symbolism throughout their buildings. They focused their architectural attention on civic structures, centered on the activities of man, and of course on temples to their gods.

Free speech, a staple of Greek life, fostered societal progress. The *Iliad* and the *Odyssey* were epic tales widely spread by word of mouth. An oracle in Athens honored and facilitated this discourse. Atlantes and caryatids (sculpted male and female figures, respectively, used as supports in the place of columns) demonstrated how the communication worked: a message was dictated to a scribe in the temple, then delivered by messenger to its recipient. It is believed that the god Hermes (called Mercury by the later Romans) initially served as the primary messenger, but that he was replaced amid rumors that he was delivering more than just messages to female recipients.

PHONE BOOTHS
BY FAMOUS ARCHITECTS

PAGE

9

OF 64 PAGES

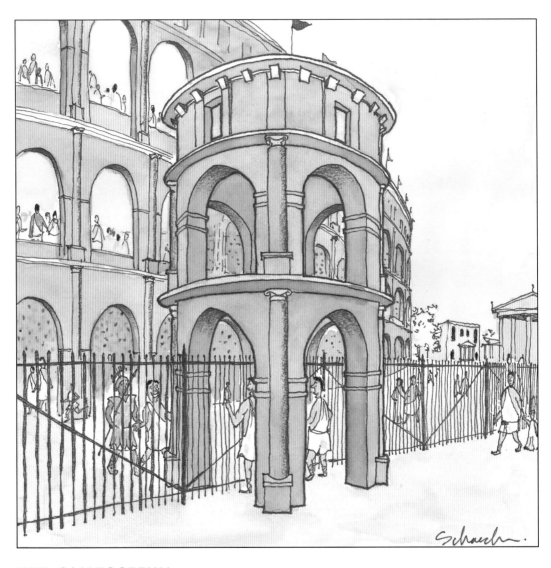

THE CALLTOSEEUM

THE ROMANS

C. 400 B.C.–A.D. 100

It is documented that the city of Rome was founded on April 21, 753 B.C. Romans were busy, ambitious people devoted to duty, religion, state, and family. Over the next few centuries, Rome became the center of an empire extending from the Thames to the Nile to the Danube and the Bosporus Strait. The Romans spread their culture (which was strongly influenced by the Greeks and, to a lesser extent, the Etruscans) across the vast empire.

Rome was indebted to Greece for its art, but the Romans were without peer or precedent in the field of engineering. They developed roads and aqueducts to connect their lands and make them inhabitable. Their architecture broke new ground, using arches, concrete, and bricks. Applied to a variety of building types, Roman architecture unified a diverse empire.

Communication was a crucial part of Roman society. However, with its hordes of citizens, Rome understood that order and security must surround the privilege of communication. This understanding is evident in the series of structures constructed around the Coliseum. Christians and prisoners of war were allowed one visit from the outside prior to each lion feeding. These visiting booths worked well at first, allowing soldier supervision and providing privacy for the conversations (which for some was their last). Unfortunately, as Roman commerce grew, the first form of telemarketing developed, and many "gladiators" spent their last hours listening to a sales pitch for freshly stomped grape wine.

PHONE BOOTHS
BY FAMOUS ARCHITECTS

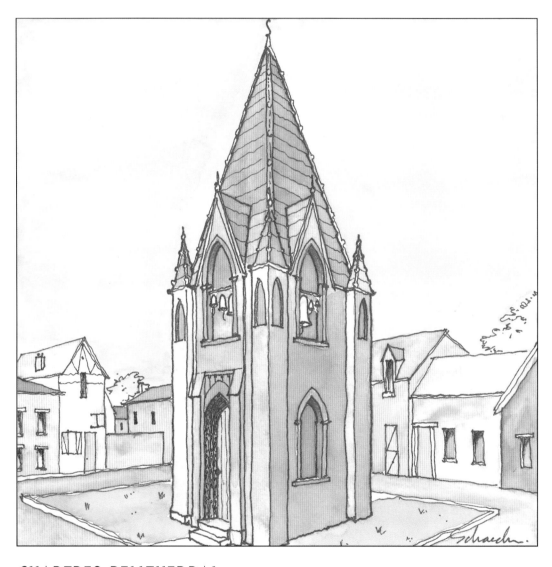

CHARTRES BELLTHEDRAL

GOTHIC

C. A.D. 1100–1400

Renaissance historians coined the term "Gothic" as a sign of contempt; they felt that the barbarians who caused the fall of Rome destroyed architectural master-pieces and introduced their own manner of building, which was dark and without just proportion or beauty. The Gothic architectural style has latterly been viewed in a more respectful light.

Gothic structures reached heights never before achieved. The emphasis was to eliminate mass and to create buildings that visually and symbolically reached for the heavens. New construction methods such as flying buttresses, pointed arches, and rib vaults helped to accomplish these feats. Visitors to Gothic churches are often overcome by wonder and awe of the spaces the "barbarians" created.

Gothic cathedrals were typically the centers of European communities; they were landmarks that symbolized the values of the city. However, in several pagan towns, Gothic architecture appeared in facilities dedicated to communication among the citizens, not between citizen and God. Used by one person at a time, the buildings were much smaller than the cathedrals, but just as magnificent. Bells were used to convey messages to others through a Dark Ages version of Morse code. Each person had an identifying code with which to determine when a message was for him or her. These booths were quite popular when first intro-duced, but uncontrollable eavesdropping and a gradual hatred for continuous bell ringing led to the destruction of these auditory treasures.

PHONE BOOTHS
BY FAMOUS ARCHITECTS

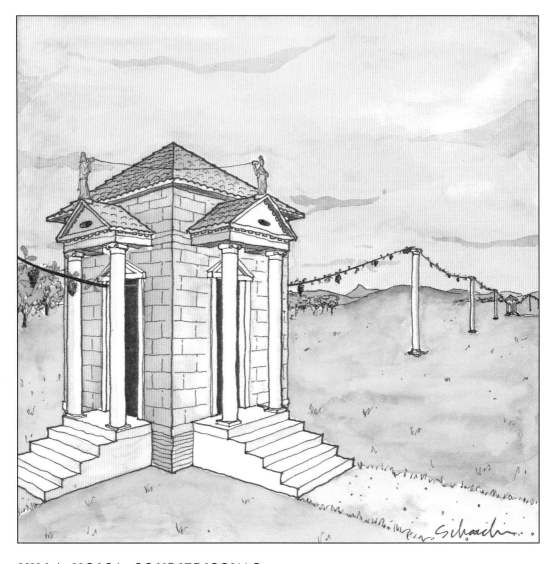

VILLA VOICA COURIERISSIMO

ANDREA PALLADIO

BORN ANDREA DI PIETRO DELLA GONDOLA, 1508, PADUA, ITALY
DIED 1580, ROME

The son of an impoverished carpenter, della Gondola was a stonemason when he met Gian Giorgio Trissino, a famous humanist poet. Trissino became Gondola's patron and gave him the name Palladio after the Greek goddess of wisdom. Palladio traveled and studied classical art and architecture, inspired by the writings of Vitruvius. His work possessed the proportions and harmonies of classical architecture, and he restored the design of the temple front.

Palladio's design principles became influential through his book *Quattro libri dell' architettura.* His influence reached the furthest of any Renaissance architect's, inspiring the Palladian style in eighteenth-century England. Although he designed many kinds of buildings, Palladio's villas in Veneto were his masterpieces.

Villas were the most abundant architectural works of the time, blanketing Italy's countryside. Renaissance thinkers used them as a way to expand the bounds of society. The grapevines of Italian wineries were found to have vibratory properties that allowed communication à la string and cup. The villas were used as ends to this pseudotelephonic system of connected grapevines. Aside from fruit fly interference, the system worked well. It is said that a popular song was written in one of the villas, at least as heard through the grapevine.

PHONE BOOTHS
BY FAMOUS ARCHITECTS

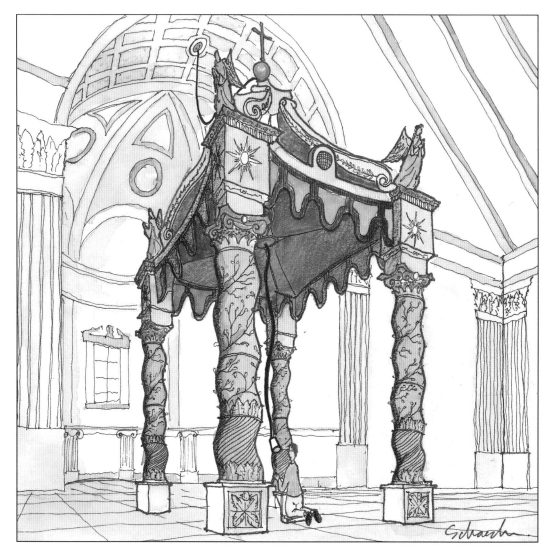

CALLACCHINO

GIANLORENZO BERNINI

BORN 1598, NAPLES
DIED 1680, ROME

Trained as a sculptor by his father, Gianlorenzo Bernini found that his talents soon surpassed the older man's; he relocated to Rome, where he became most influential. Bernini was gifted in architecture, sculpture, and theater design. Considered the creator of the Baroque style, he provided new dynamic forms, lavish and magnificent, with highly articulated sculptural reliefs that seem alive.

Bernini's works utilized drama and false perspective to engage the spectator while also working within Renaissance principles. The Catholic Church was his primary commissioner. The Baroque style revitalized the Church as a richly endowed entity and demonstrated the rewards of faith.

Most of Bernini's works can be found at St. Peter's in the Vatican. One of his finest structures is the Callacchino, a grand confessional in the center of the lowest southwestern wing to the right. This masterpiece uses a baroquely glorified cup-and-string telephone that allows the Pope to hear confessions in the comfort of his papal suite. The canopy gives those doing the confessing the impression that they are speaking directly with God. In fact, a painting of God listening to a cup, similar to Michelangelo's *Creation of Adam,* was considered for the Callacchino ceiling, but it could not be realized before Bernini received his own call from above.

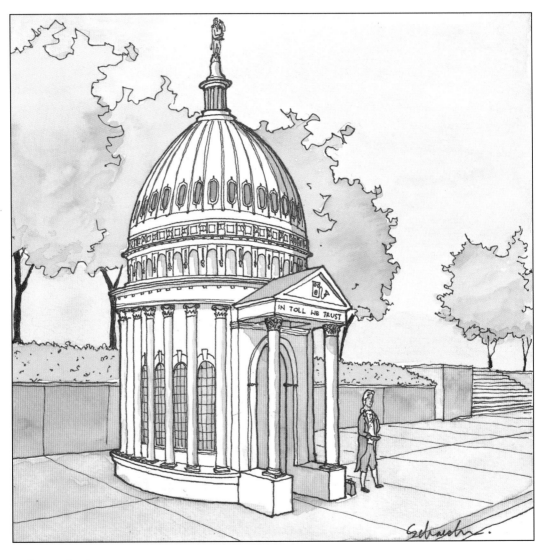

CAPITOLL

LATROBE, BULFINCH, & WALTER

BENJAMIN LATROBE: BORN 1764, LEEDS; DIED 1820, NEW ORLEANS
CHARLES BULFINCH: BORN 1763, BOSTON; DIED 1844, BOSTON
THOMAS USTICK WALTER: BORN 1804, PHILADELPHIA; DIED 1887, PHILADELPHIA

These architects never collaborated on design; rather, they worked in succession to complete the United States Capitol—a building with a long, storied history fraught with troubles because of the repeated appointments of architects to supervise execution of a design to which they had no personal commitment. Latrobe, America's first professional architect, was appointed to oversee repairs and modifications to the existing Capitol in 1803. He remained under contract until 1817 and was responsible for designing a connection of the two wings and enhancing the interiors.

Bulfinch succeeded Latrobe, overseeing the construction of the center and its dome. He followed Latrobe's design except for increasing the dome's height and adding some committee rooms. His work ended in 1829. Twenty-two years later, the legislature decided to add more space for new state delegates. Walter was chosen through a competition to add to the two wings and enlarge the central dome to its current form.

Oddly, these architects were responsible for other U.S. buildings in the same successive manner. The government saw an opportunity to aid funding of the construction on Capitol Hill. The first taxable communication booth (pay phone) was created in the mold of the nation's statehouse and all that is right in democracy. And it underwent only three renovations.

PHONE BOOTHS
BY FAMOUS ARCHITECTS

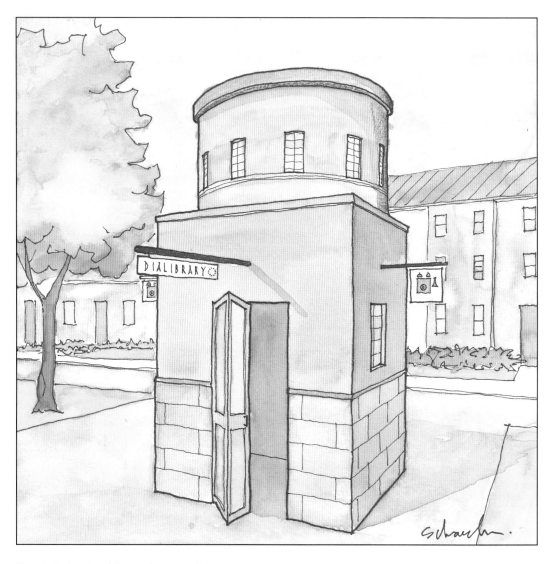

STOCKHOLM DIALIBRARY

REVISED	BY

ERIK GUNNAR ASPLUND

BORN 1885, STOCKHOLM
DIED 1940, STOCKHOLM

Asplund studied as a painter before attending the Royal Institute of Technology in Stockholm to pursue architecture. He furthered his education by traveling throughout Europe. Most of his work was obtained through competitions. Asplund went on to teach at the Royal Institute and edit a Swedish architectural magazine.

Through his work, Asplund sought to direct people to "a new architecture and a new life." Considered Sweden's leading architect, he embraced Modernist principles: his work utilized basic geometric forms stripped of detail, with expansive space. In later life, Asplund's philosophy of architecture became more traditional and functionalist.

The Stockholm Library, Asplund's most renowned design, attracted keen admiration from the citizenry; they requested that it be replicated in other structures throughout Sweden. The Dialibrary is one such structure. It is the first phone booth to contain a small library, with books on phone etiquette and a virtual smorgasbord of phone books from every European nation. Modernizations over the years have included songs by the 1970s Swedish supergroup ABBA piped in to play when the phone is on hold.

PHONE BOOTHS
BY FAMOUS ARCHITECTS

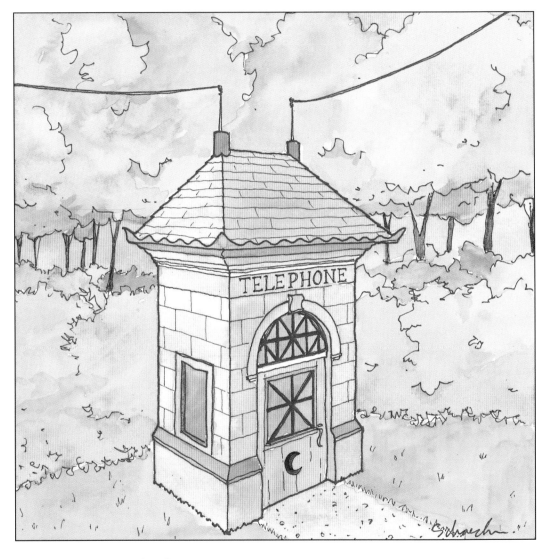

THE OUTBELLHOUSE

McKIM, MEAD & WHITE

CHARLES McKIM: BORN 1847, CHESTER COUNTY, PENNSYLVANIA; DIED 1909, ST. JAMES, NEW YORK
WILLIAM MEAD: BORN 1846, BRATTLEBORO, VERMONT; DIED 1928, PARIS
STANFORD WHITE: BORN 1853, NEW YORK CITY; DIED 1906, NEW YORK CITY

At the turn of the twentieth century, McKim, Mead & White were the premier archi-tects in the United States. McKim studied architecture at the École des Beaux-Arts in Paris. On his return, he was employed by H. H. Richardson. He later worked on his own for several years before forming a partnership with Mead and White, who had also worked in Richardson's office, in 1879.

The trio's architecture involved clear geometry and order. They utilized classical ideas of planning and symbolism for their designs while incorporating elements of American Colonial style. The firm won commissions for many notable civic projects, including the Boston Public Library and Pennsylvania Station in New York, and exerted considerable influence in residential architecture.

McKim, Mead & White designed homes for the aristocracy. Formal in design, these structures typically featured the latest in contemporary technology. The Out-bellhouse is an example of one such breakthrough, combining the new telephone system with the ever-important privy. This secluded edifice allowed executives to conduct two types of business at once: multitasking at its best. The firm's classical design brought dignity to the tasks at hand, although people on the other end of the line may have disagreed. Many were thankful that Bell abandoned his studies for transmitting smells across phone lines.

PHONE BOOTHS
BY FAMOUS ARCHITECTS

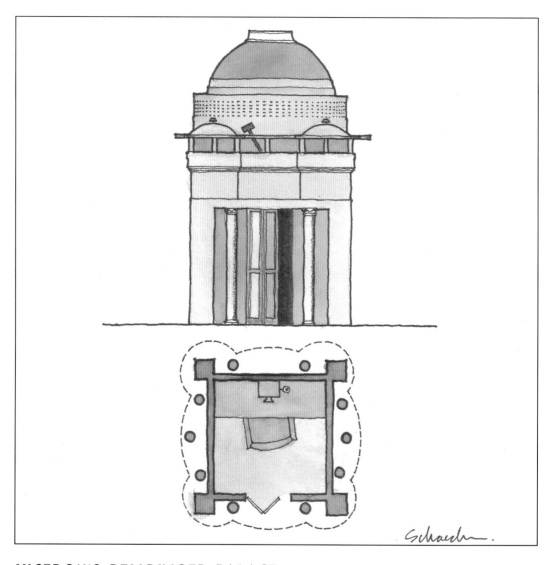

VICEROY'S BELLRINGER PALACE

SIR EDWIN LUTYENS

BORN 1869, LONDON
DIED 1944, LONDON

Lutyens took an interest in architecture at the early age of fifteen and studied it under Sir Ernest George. Initially lacking professional experience, he began his own practice in 1889. His bride, Gertrude Jekyll—a well-known garden designer—had the social connections to help Lutyens acquire many commissions in England. He was knighted in 1918, at the height of his fame.

Lutyens' early residential designs are notable for their historical references in materials and forms. As his success grew, he developed a mastery of classical language in architecture and an increasing commitment to the discipline of the Orders. Knighthood brought with it many public and commercial commissions. Lutyens' greatest work was in the design and planning of New Delhi, the new capital of India; here he fused his interpretations of classical order with Indian elements in a sensitive fashion.

Begun in 1913, the Viceroy's Palace has proven to be one of Lutyens' most celebrated works. To suffuse the city with the symbology of benign governance, the design was mimicked in New Delhi telephone booths. These incorporated large bells over the door that signal both incoming calls and the booth's vacancy. The column locations in the plan demonstrate Lutyens' admiration for the telephone's rotary dialing system.

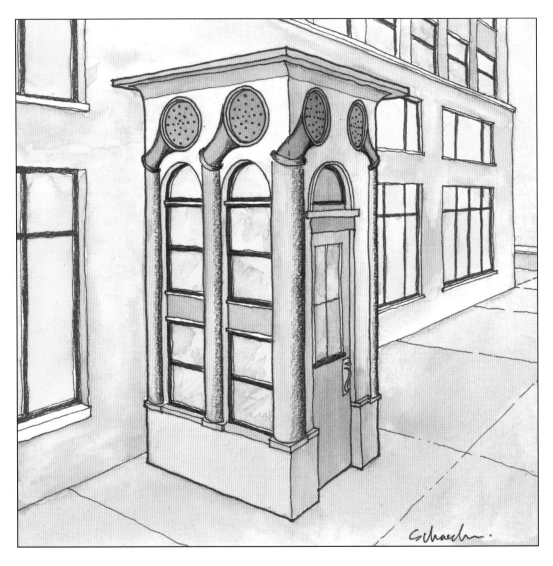

GUARANTY PHONE PANTRY

LOUIS SULLIVAN

BORN 1856, BOSTON
DIED 1924, CHICAGO

Educated in architecture at MIT and the École des Beaux-Arts in Paris, Sullivan formed a partnership with Dankmar Adler in Chicago; they practiced together for sixteen years, until Adler's retirement in 1895. Sullivan was the principal designer, while Adler was strong in engineering skills. Sullivan was one of the most influential architects of the Early Modern movement and the Chicago School.

Buildings by Sullivan are characterized by simple geometric forms with exquisite ornamentation based on organic symbolism. His famous credo, "Form follows function," extended beyond functional and structural expressions: to Sullivan, architecture was an expression of a natural force addressing technical challenges, often through biomorphic designs.

When asked to design a phone booth, Sullivan sought to demonstrate the telephone's classical aesthetic to the public. The Guaranty Phone Pantry has a classical base, shaft, and capital, and its verticals recall the phone stem; the architect called these "callumns." The vents over the windows are literalist interpretations of contemporary telephone transmitters. Visitors to the booth immediately connected the phone's familiar image with the ubiquitous and equally recognizable Greek Revival columns. After completion, Sullivan summarized the design by observing that "Form follows function, and I like the form of a phone."

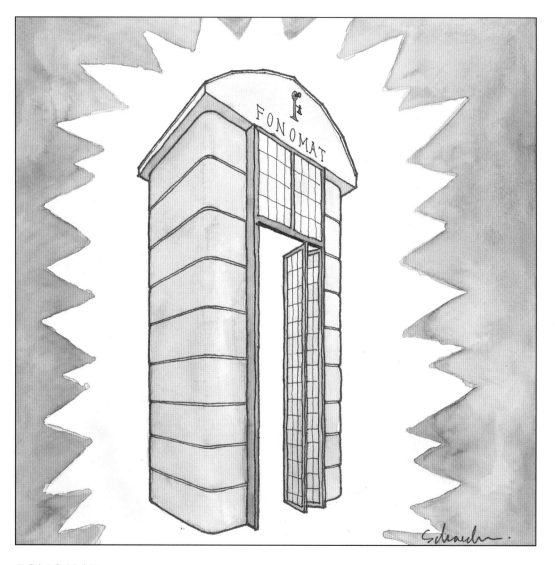

FONOMAT

PETER BEHRENS

BORN 1868, HAMBURG
DIED 1940, BERLIN

Trained as an artist, Behrens eventually abandoned painting to work in the graphic and applied arts. He accepted a leadership role at a Düsseldorf design school, where he integrated a new geometric abstraction into design and also became very influential to early Modernist architecture.

Behrens' most notable work was as an artistic adviser to Berlin's provider of electricity. In this capacity, he oversaw the design of everything built, used, or made by the company. His designs were among the first to base simple and effective style on the innovations of modern construction, bringing life to industrial design. Many future famous architects, including Gropius, Mies van der Rohe, and Le Corbusier, apprenticed under Behrens.

It was Behrens' design for a phone booth that opened the bifold doors for the Early Modern movement. Similar to his AEG factory, the Fonomat had a classical form with a protruding glass curtain wall that expressed the newest advances in materials and the Modernist aesthetic. Controlling the presentation of the design helped Behrens to popularize the booths (and thus to advance his ideas before the public). Fonomats were glamorized to proclaim the promises of the future. They represented the cutting edge of societal trends. If you hadn't been in one of these proud boxes, you were going to miss the boat to a Modernist New World. The only thing missing from Behrens' promotional effort was an endorsement from a third-tier celebrity.

PHONE BOOTHS
BY FAMOUS ARCHITECTS

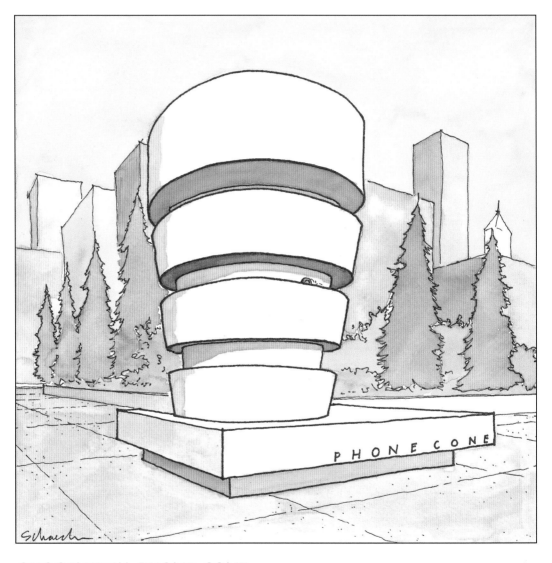

GUGGENHEIM PHONE CONE

FRANK LLOYD WRIGHT

BORN 1867, RICHLAND CENTER, WISCONSIN
DIED 1959, TALIESIN WEST, SCOTTSDALE, ARIZONA

Frank Lloyd Wright has been called the greatest architect ever to have lived. He designed more than 1,100 projects over the course of a seven-decade career. Wright briefly studied engineering at the University of Wisconsin; he then went to Chicago to work as a draftsman for J. L. Silsbee and later for Louis Sullivan, whom he called "Lieber Miester"—beloved master.

Wright broke many fundamental architectural conventions. His Prairie Style houses' floor plans had free-flowing open forms with overlapping spaces instead of traditional rooms. He created the philosophy of "organic architecture," which maintained that a building's form and materials should be closely related to its natural surroundings. His genius gave rise to many innovations in design, from structural innovation to air-conditioning.

One of Wright's greatest designs was the Guggenheim Museum in New York City. Here, visitors take an elevator to the top floor and make their way down a spiral ramp lined with artworks. The presence of the ramp—the museum's core—is evident from the exterior.

The building's form became so recognizable that the phone company requested that it be adapted for phone booths. Finding pay phone design as satisfying as the Guggenheim project, Wright incorporated the ramp as a spiraling tube around the telephone user: the means by which change was inserted to pay the toll. Is it any wonder that he is considered the ultimate architectural genius?

PHONE BOOTHS
BY FAMOUS ARCHITECTS

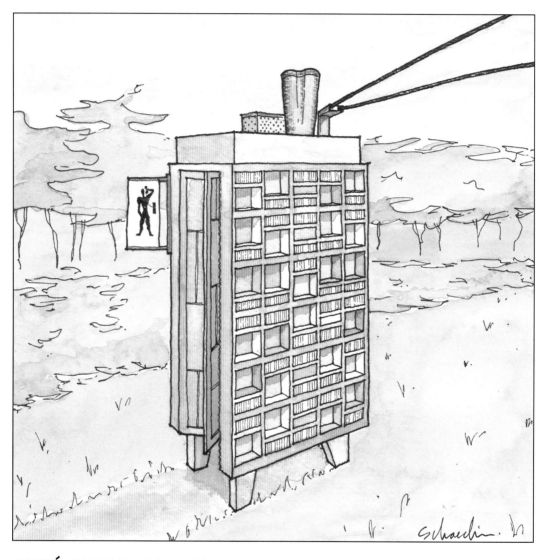

UNITÉ D'CONVERSATION

REVISED	BY

LE CORBUSIER

BORN CHARLES-ÉDOUARD JEANNERET, 1887, LA CHAUX-DE-FONDS, SWITZERLAND
DIED 1965, CAP MARTIN, FRANCE

Trained as an artist, "Corbu" traveled throughout Europe absorbing the cultural and artistic life. He studied under architect August Perrett and developed an interest in synthesizing the arts. A leader of High Modernism, Le Corbusier combined classical ideas of form, futuristic mechanical symbolism, and abstract art.

To Corbu, architecture was a human response to built construction, created by the play of light on sculpted masses. The Machine Age was integral to his design philosophy. His famous dictum, "A house is a machine for living in," pioneered functionalist architecture. Brute concrete was a primary material in his designs. He was also an influential urban planner, with visions of combining nature and machine. Large multiuse facilities were conceived, connected by multilevel highways and infilled greenery.

Le Corbusier's large utopian visions were realized with his Unité d'Habitation, a building with 1,600 living units, shops, cinemas, and recreational areas. It was designed as a communal, self-sufficient, shiplike fortress removed from the perils of the world. Corbu duplicated these effects with his phone booth design. His fortress imagery symbolically conveys the message of seclusion—from eavesdroppers, it is assumed. The colorful variation of the cells represents a switchboard. However, upset with the work's service, Corbu observed that "a phone booth is a machine to lose money in."

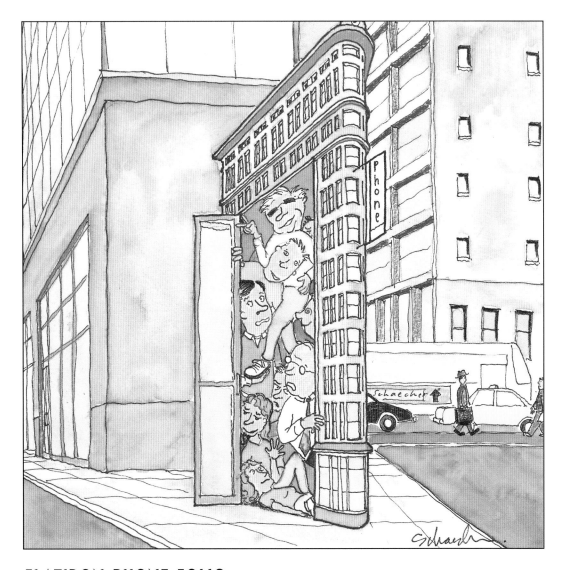

FLATIRON PHONE FOLIO

DANIEL BURNHAM

BORN 1846, HENDERSON, NEW YORK
DIED 1912, HEIDELBERG

Raised and educated in Chicago, Burnham worked under architect William LeBaron Jenney, a pivotal figure in the development of skyscraper design. In 1873 he formed a partnership with John Root that led to several influential Chicago School projects. After Root's death, Burnham continued the practice and achieved notoriety as a city planner when he oversaw construction of the 1893 World's Columbian Exposition buildings.

The development of the curtain wall and steel frame construction were crucial to the design of skyscrapers, and Burnham and his firm were at the movement's leading edge. The skeletal nature of these buildings was deliberately expressed. Burnham turned to classical models to help shape his designs, attracting criticism from some other architects.

One of Burnham's most famous designs is the Flatiron Building in New York, named for its triangular shape. It incorporates both Italian and French Renaissance motifs, and its unique footprint led the telephone company to mass-produce scaled-down replicas as phone booths around the city. The triangular plan fits conveniently at many awkward street intersections. Its slenderness has made it a popular venue for people-cramming competitions. The current record is twenty-two, ironically the same number of stories in the actual building.

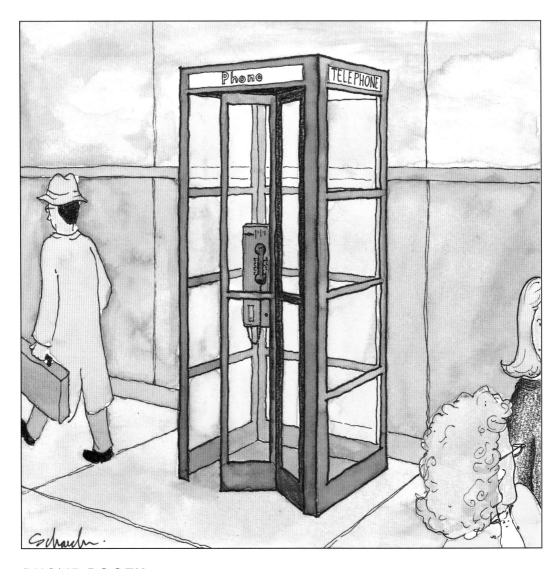

PHONE BOOTH

LUDWIG MIES VAN DER ROHE

BORN 1886, AACHEN, GERMANY
DIED 1969, CHICAGO

During his teens, Mies van der Rohe worked as a stonemason with his father. From 1908 to 1912, in the employ of Peter Behrens (alongside Le Corbusier and Gropius), he developed a design philosophy based on structural rationalism. With no formal training, Mies became one of the most influential architects of the Modern movement.

Mies was the innovator of the glass-skin-over-steel-skeleton building. He strove to design contemplative spaces based on material honesty and structural integrity. His term as director of the Bauhaus helped to popularize his theories of design—including the minimalist truism that "less is more," the essence of the International Style prominent during the mid-twentieth century. A typical Mies design was a glass box that expressed its structural framework.

Much as with the chicken and the egg, it is hard to determine whether Mies' phone booth design was influenced by the typical mass-produced phone booth or vice versa. Obviously, the typical American phone booth fits the mold of Mies' theories, and if he did not design the prototype, he should have. His phone booth is a simple, elegant glass box that provides acoustic privacy but visual accessibility. Its universality allows the booth to be set down anywhere without looking out of place. The design represented Mies' approach so much that he carried a booth with him to interviews to demonstrate his principles to potential clients.

PHONE BOOTHS BY FAMOUS ARCHITECTS

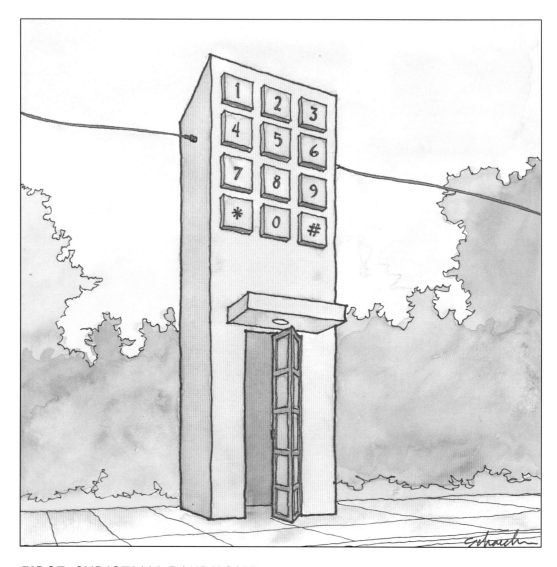

FIRST CHRISTIAN PAYPHONE

ELIEL SAARINEN

BORN 1873, RANTASALMI, FINLAND
DIED 1950, BLOOMFIELD HILLS, MICHIGAN

Saarinen studied architecture at Helsinki Polytechnic. Having established a prac-
tice with fellow students Herman Gesellius and Armas Lindgren, he achieved
international acclaim. In 1923 he immigrated to the United States, where he
designed and then taught at Cranbrook School in Michigan, an academy initially
conceived to be similar to the Bauhaus. Toward the end of his career he worked
in partnership with his son Eero.

Saarinen's designs expressed the values of cultural symbolism in materials
and form. His early works reveal the influence of European Art Nouveau com-
bined with Nordic sensibilities in their sleekness and use of regional materials;
abstracted classical style exhibited the clean massing and heaviness of tradi-
tional Finnish buildings. Because of these simple massings, Saarinen was often
associated with Minimalism.

Saarinen's monumental phone booth design again demonstrated his aver-
sion for simple massing. His design anticipated and inspired the now common-
place touch-tone format. In a Venturiesque manner, Saarinen used the building
as a billboard to exhibit the cutting-edge technology that was now at everyone's
fingertips. His phone booth was a great testing platform for his design work.
Saarinen created his famous First Christian Church tower in Columbus, Indiana
(a famous-architect Mecca), after the booth's design was favorably received.

PHONE BOOTHS
BY FAMOUS ARCHITECTS

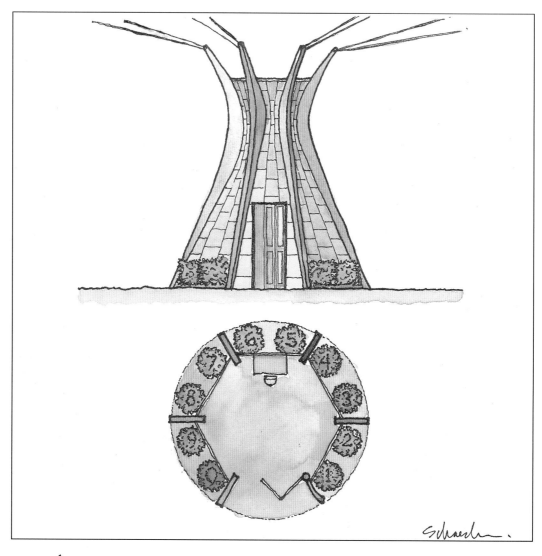

BRASÍLIA BOOTHEDRAL

OSCAR NIEMEYER

BORN 1907, RIO DE JANEIRO

Niemeyer studied architecture at the Escola Nacional de Belas Artes in Rio de Janeiro. Upon graduation, he joined a team of Brazilian architects who collaborated with Le Corbusier to design the new Ministry of Public Instruction building. This interaction influenced his approach toward architecture.

Niemeyer became Brazil's foremost Modernist architect. His monumental works for Brazil's capital city, Brasília, captured the essence of the culture. These free-flowing forms, seen as artistic gestures with underlying logic and substance, utilized reinforced concrete to achieve their plasticity. Overall, Niemeyer's work is characterized by this plasticity, with soaring spans and structural ingenuity. He was awarded the Pritzker Architecture Prize for his lifetime achievements.

Brasília's building designs garnered international acclaim for Niemeyer. His innovations in structures and forms immediately rang a bell for the national telephone company. With Niemeyer's booth design, telephone communication became a spiritual experience. The free form of the space captured the energy and vibrancy required of long-distance auditory communication, while its inward focus stressed the individual nature of such communication. Niemeyer's artistic use of coffee bean shrubs, evoking a rotary phone, tied his country's culture to his phone booth and demonstrated the sensitive side of Modernism.

PHONE BOOTHS
BY FAMOUS ARCHITECTS

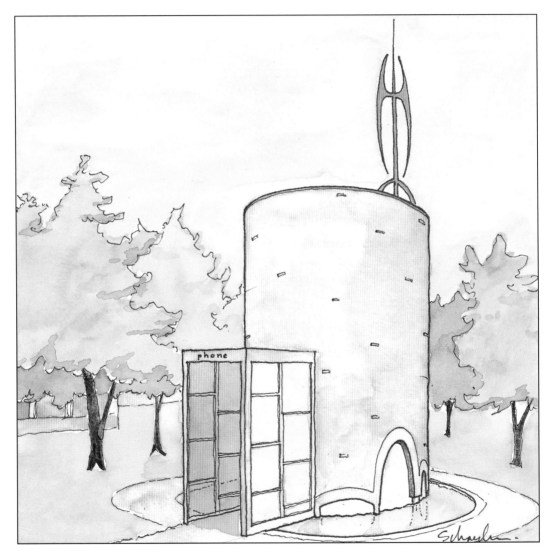

KRESGE CHATTERBOX

EERO SAARINEN

BORN 1910, KIRKKONUMMI, FINLAND
DIED 1961, ANN ARBOR, MICHIGAN

Eero was the son of the famous architect Eliel Saarinen and of Loja Saarinen, a gifted sculptor and artist. He was raised in a house that stressed drawing, painting, and professionalism. After studying architecture at Yale and then serving a two-year fellowship in Europe, Eero practiced in partnership with his father for several years. His winning entry for a monument in St. Louis, Missouri, established him as an innovative, independent architect.

Saarinen refused to be constrained by preconceived notions. His works moved easily between International Style and Expressionism. Striking, structurally innovative, sculptural forms, each with its own unique design solution, often drew upon their function for their imagery. Although he died young, at fifty-one, Saarinen left many masterpieces that expanded the boundaries of architecture.

A landmark on the MIT campus, the Kresge Chatterbox is a windowless cylinder with a surrounding moat. Dancing arches along the base of the structure allow light to be reflected from the moat to the interior walls. The atmosphere of the interior has an aura of "spiritual unworldliness." Originally a place for solitary meditation, it now exists as a phone booth. The interior's shimmering glow is now supplemented with a gently glowing touch-pad telephone. The sculpture atop the facility was modified into an antenna with one-inch wire. Saarinen would surely approve.

PHONE BOOTHS
BY FAMOUS ARCHITECTS

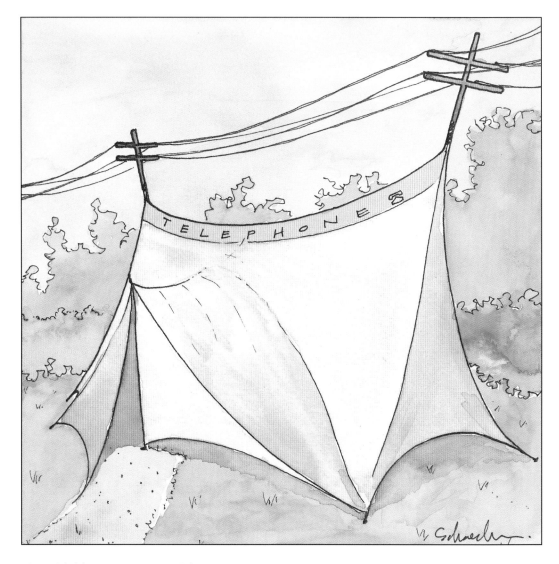

GERMAN TELE-VILION

FREI OTTO

BORN 1925, SIEGMAR, GERMANY

Frei Otto attended Schadow School in Berlin as a trainee mason from 1931 to 1943. Back in Berlin after serving as a pilot in World War II, he attended the Technical University and then established an architectural practice. In 1957 he founded the Development Center for Lightweight Construction.

Otto is not a conventional architect. Throughout his career he has exhibited a gift for designing light, tentlike structures. During the 1950s he developed models to define and test complex tensile shapes when analysis of such structures was in its infancy. His design for the German pavilion at the 1967 Montreal Exposition included the first large-scale cable-net roof. Otto also developed the first convertible roof for use over arenas, in which a variable geometry permitted the roof to be retracted at will. His research has developed into computer-based mathematical formulas used to determine exact shapes of these tensile structures, and his structural innovations have brought the tent in line with other twentieth-century advances.

Otto's breakthroughs in tensile designs paralleled the developments in the communications industry. The marriage of the two was a natural fit in the form of rural phone booths. Using existing telephone poles, Otto stretched a membrane over salvaged phone cables to form the phone tent. These facilities line the Autobahn and were originally used to summon roadside assistance. After the Germans fitted each unit with a keg for convenience, Tele-Vilions proved to be the most popular building type in the country.

PHONE BOOTHS
BY FAMOUS ARCHITECTS

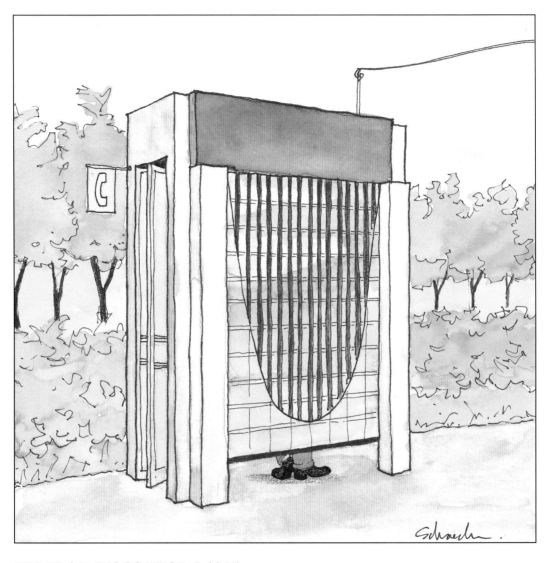

FEDERAL DISCOURSE BANK

GUNNAR BIRKERTS

BORN 1925, RIGA, LATVIA

After attending the Technical University in Stuttgart, Birkerts worked with vision-
ary architect Eero Saarinen in Michigan. Birkerts established his own firm and
continues to flourish as one of the country's foremost Modern architects. He
served on the faculty at the University of Michigan, and he has also taught at the
Universities of Illinois and Oklahoma.

Birkerts' works do not fall into one particular style. Borrowing from
Saarinen, his designs are very expressive, emphasizing dynamic flow and the
illuminations of space. Birkerts has done many major projects involving many
different building types. His architecture typically embodies a symbol of the
building's function.

Birkerts' phone booth design expresses the dynamic flow of information
through phones. The building consists of two piers with a bridge element span-
ning them. The bridge, an inverted arch of real telephone cable suspended from
the piers, supports the booth's sidewalls. Elevating the central mass clear of the
ground allows potential users to tell from a distance if the facility is in use: the
user's feet are visible, as with toilet partitions. The bridge element symbolizes
the telephone system's connection of two different entities.

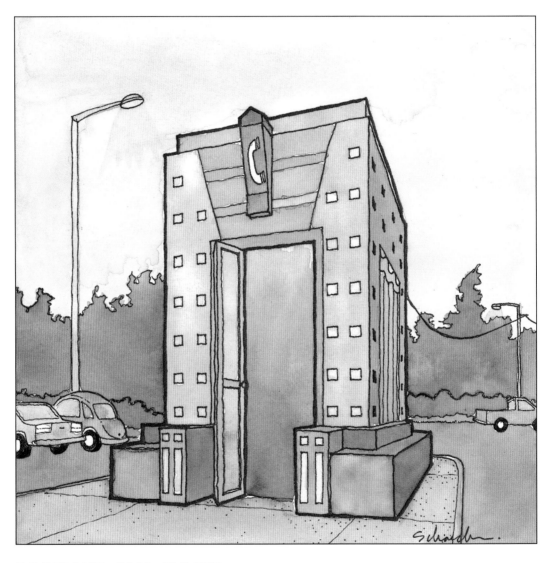

PORTLAND CALL CLOSET

MICHAEL GRAVES

BORN 1934, INDIANAPOLIS, INDIANA

Graves attended the University of Cincinnati and Harvard University, then won a two-year fellowship at the American Academy in Rome. He returned to New Jersey to start his own practice and teach at Princeton University.

Graves was a member of a young group of architects, called the New York Five, that reinterpreted the Modern style into neoclassical forms, ushering in the Postmodern style. The architectural language he developed for his designs focuses on abstraction of historical forms and the use of color. Graves' popularity extends beyond his architectural works: he is also very well known for applying his design principles to common household products available at popular marketplaces.

One of Graves' significant early works was his Portland Building for government offices. This building became the model for Postmodern design. As the style spread during the 1980s, every community yearned to make a pastel statement of its own. Graves provided a miniversion of the building, functioning as a phone booth, to send to these cities. It is believed that the mass production of these postmodern icons may have been the spark for his interest in commercial product design. The Call Closets' function was secondary to the presence they provided among communities. People liked to talk about them, even more than they liked to talk in them.

PHONE BOOTHS
BY FAMOUS ARCHITECTS

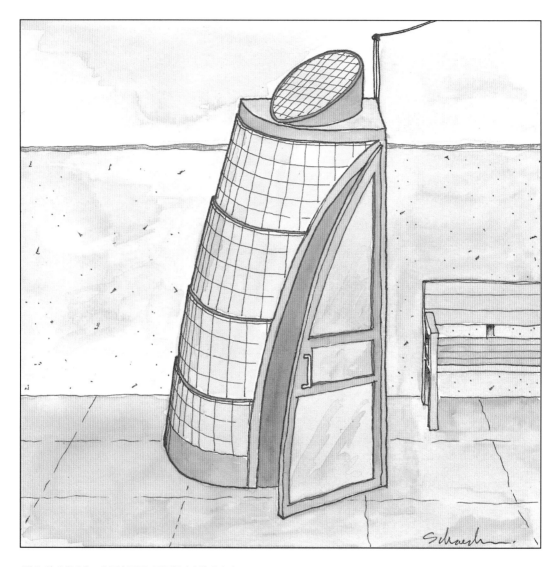

ILLINOIS STATE TERMINAL

HELMUT JAHN

BORN 1940, NUREMBERG, GERMANY

Jahn trained at the Technische Hochschule in Munich, then immigrated to the United States and studied for one year at the Illinois Institute of Technology under Mies van der Rohe. He joined the office of C. F. Murphy in Chicago in 1967, and became partner and director of design six years later. The firm was renamed Murphy/Jahn in 1981, when he became a principal. Two years later, he was named CEO.

During the 1960s, the firm achieved success with many distinguished buildings in Chicago, using a language of Miesian geometry. Jahn's design approach evolved over time to stress the intuitive nature of creative rationalism. He utilizes elements from wide-ranging historical references to relate to a building's context. His designs often overwhelm visitors with their large scale, vibrant colors, and effective use of sophisticated construction techniques.

One landmark project of Jahn's was the State of Illinois Center in Chicago, which gave the state a recognizable identity. Its views inside and out have awed visitors since its completion. The local phone company heard the phrase "Insert another quarter, please" ringing loudly from the mass appeal of this building. They filled the city with hundreds of replicas of the design, adapted as phone booths. To address confusion about the governmental imagery of the booths, the phone company posted signs reading, "This is a free-enterprise phone terminal —please make a note of it."

PHONE BOOTHS
BY FAMOUS ARCHITECTS

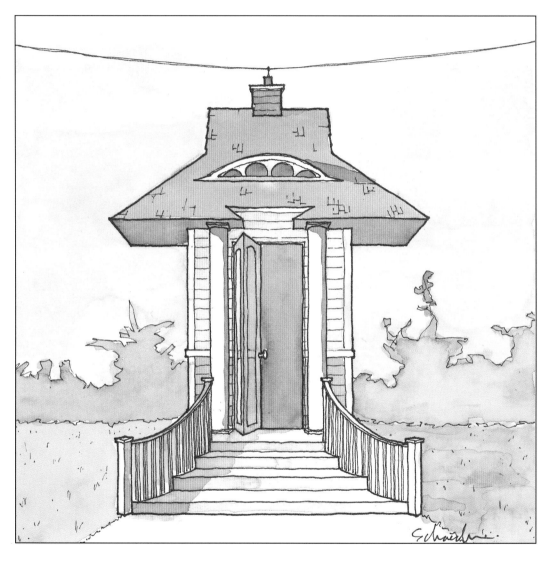

TELEMARKETING-FREE KIOSK

ROBERT A. M. STERN

BORN 1939, NEW YORK CITY

Stern studied architecture at Columbia University and Yale University. He worked briefly with architect Richard Meier until he established his own practice, with John Hagman, in 1969. Stern also taught at Columbia and Yale, and he was named dean of the Yale School of Architecture in 1998.

Stern was an important figure in the development of Postmodernism. His designs married classical building elements to contemporary contexts, typically with graceful lines and an occasional hint of satire. His later works display a more scholarly revival of styles, from Spanish Colonial to Greek Revival to Georgian, whichever is most appropriate for the building's context. The majority of his work is in the residential market, although he has also designed many significant larger projects.

The exclusive estates of the Hamptons, on Long Island, showcase several of Stern's houses. Public amenities in this area needed to be sensitive to the designs of these upscale houses; Stern was called upon to provide many of these facilities. His phone booths demonstrate his skill at integrating classical styles with modern building techniques. The image of a temple is communicated in his kiosks, with their stark symmetry and familiar form, suggesting that telephonic communication has a higher purpose. It is his attention to detail that stands out, however; the unique eyebrow dormer appears to be a giant phone dial surfacing through the roof. Residents of the Hamptons pay a minor surcharge to ensure that no telemarketing calls are made or received from these booths.

PHONE BOOTHS
BY FAMOUS ARCHITECTS

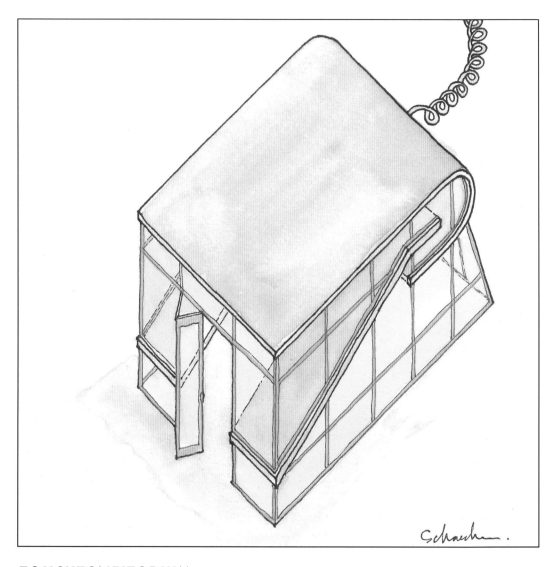

TOUCHTONEITORIUM

REM KOOLHAAS

BORN 1944, ROTTERDAM, NETHERLANDS

Koolhaas was schooled in architecture at the AA (Architectural Association) School in London. He established the OMA (Office of Metropolitan Architecture) in 1975. Koolhaas' writings on architecture brought him renown before he had had any projects constructed. *Delirious New York,* published in 1978, analyzed the culture of congestion and the architecture of a metropolis. His ideas about architecture and urban planning often stirred controversy by straying outside the bounds of convention.

Although Koolhaas was labeled a Deconstructivist during the 1980s, his work focuses on addressing the changing elements of architecture, scale, population, and technology. As talented an architect as he is a theorist, he believes that social progress is informed by the idea of a metropolis as a self-generating system of signs and symbols. His projects look to a new urbanism that celebrates the "end of sentimentality" toward the historical core of today's society.

Koolhaas' urban phone booth evinces his embrace of new forms to facilitate the growth of society. The building itself serves as a symbol of its function. It turns its back on historical precedents and takes advantage of today's technology. The Touchtoneitorium (factory for making phone calls) has proven to be a popular place for working parents to conduct business. The dynamic poured-concrete planes serve as a playground for children within the box but maintain separation from the actual phone—pure genius!

PHONE BOOTHS
BY FAMOUS ARCHITECTS

PAGE

55

OF 64 PAGES

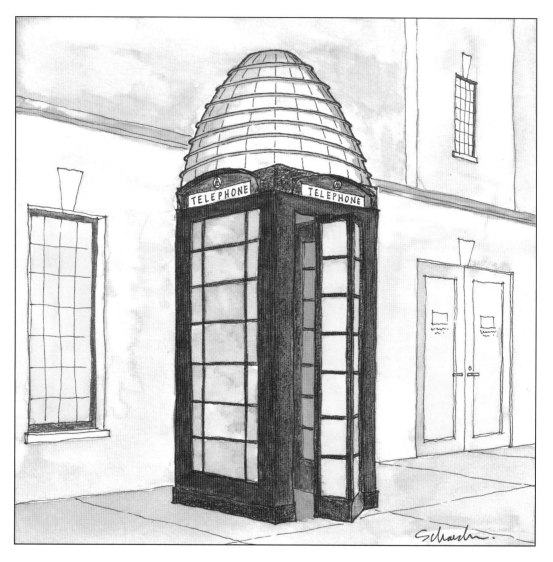

RINGERSTAG

SIR NORMAN FOSTER

BORN 1935, MANCHESTER, ENGLAND

Foster served in the Royal Air Force and held several odd jobs before attending Manchester University's School of Architecture and Planning. He won a fellowship to Yale University, where he earned his master's degree and met fellow architect Richard Rogers. They became close friends and worked together, with their wives, for a firm called Team 4 until 1967, when Foster Associates was founded.

Foster's work has shown uncompromising exploration of technological innovations and forms. His designs emphasize repetition of modular units that can be constructed off-site. Passion for the environment is evident in his designs' focus on the users' well-being. Foster continues to invent artistic responses to complex building programs. England acknowledged his immense contributions to his field by knighting him in 1990.

The British phone booth is a cultural icon; miniatures of this familiar scarlet cast iron box are even sold as souvenir refrigerator magnets. However, today's communication technology and imagery have changed. Foster was selected to redesign this street-life staple and usher it into the future. His design kept the original imagery intact but added a glass dome incorporating the latest technological achievements. His design has won critical acclaim for its sensitivity, but the public has not yet warmed up to the image shift. British tabloids have suggested that only very large-headed women who have a need for the giant hair dryer on top should use the booths.

PHONE BOOTHS
BY FAMOUS ARCHITECTS

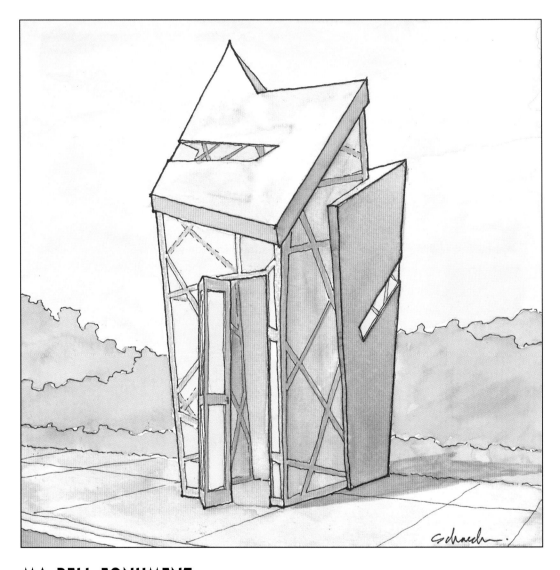

MA BELL FONUMENT

DANIEL LIBESKIND

BORN 1946, LODZ, POLAND

Born to Holocaust survivor parents in Poland, Libeskind immigrated to Israel in 1957. He studied music there, as well as in New York, and became a virtuoso pianist before studying architecture at Cooper Union and going on to take a postgraduate degree in history and theory of architecture from Essex University.

Libeskind had an extensive career as an architectural theorist and critic before his first project was constructed. He lectured and taught at several universities. Not until 1998 was his first building opened. A visionary architect who takes a multidisciplinary approach to his work, he has remarked on his "abhorrence toward conventional architecture." During the 1980s, he was included in a group of architects called Deconstructivists. In 2003, winning the competition for the reconstruction of Ground Zero made him the focus of much debate and support.

Libeskind's designs typically consist of entwined, sharply angled masses evoking a spirit and excitement in the viewer. More than 300,000 people visited his Holocaust Museum, recently opened in Berlin, before any exhibits were installed. His phone booth design evokes similar vision and inspiration. The fragmented vision of the booth represents the complex web of today's telephone systems. Inside the booth is an eloquent description by Libeskind of the rationale behind his design. However, the summary is rather lengthy: there was no room for a phone, so the Ma Bell Fonument is really a prank phone booth.

PHONE BOOTHS
BY FAMOUS ARCHITECTS

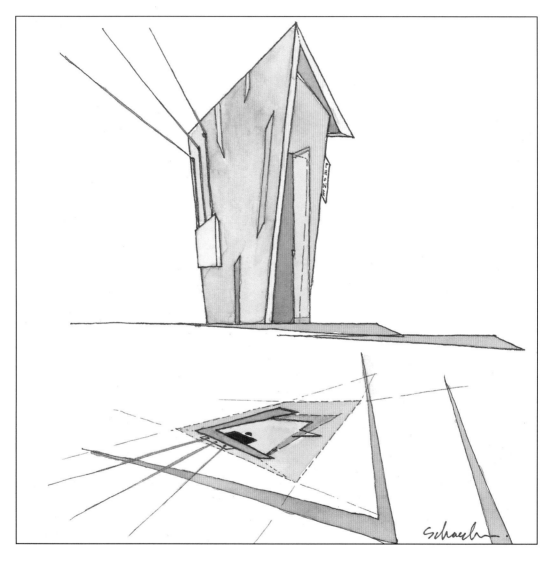

FROZEN MOTION PHONEBOOTH NOTION

ZAHA HADID

BORN 1950, BAGHDAD, IRAQ

Iraqi-born British architect Zaha Hadid studied at the Architectural Association in London from 1972 to 1977, then worked with Rem Koolhaas at the OMA. She started her own practice in 1979 and returned to the AA to teach from 1980 to 1987. Hadid has won several design competitions throughout the world. The Contemporary Arts Center in Cincinnati, completed in spring 2003, was her first project to be constructed in the United States.

The Cubism, Futurism, and Constructivism art movements inspire Hadid's works. Her designs are based on the paintings and drawings that she generates for each project; they explore the boundaries of architecture and typically embody fragmented geometric forms engaging and defining the space around them. Hadid seeks innovative ways to use light, space, and shadow; she has described her works as "frozen motion" to explain the dynamic forms and the intent of visitors' interactions.

Originally, many people considered Hadid's designs unbuildable, paper architecture. She now has many examples of built works that are as dramatic as her artwork. Her phone booth design is a skewed form representing the movement of communication through time. It is rumored that to prove herself capable of great, buildable architecture, she wrote self-promotional graffiti inside the booth: "For a good design, call Zaha."

PHONE BOOTHS
BY FAMOUS ARCHITECTS

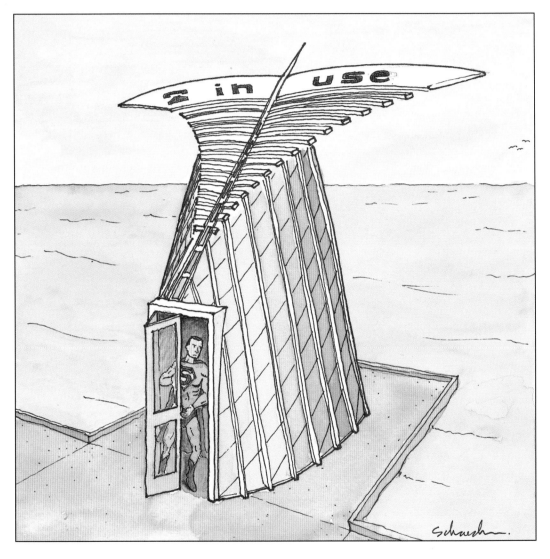

MILWAUKEE TALKIE STATION

SANTIAGO CALATRAVA

BORN 1951, VALENCIA, SPAIN

Calatrava attended art school in Valencia before studying architecture at the Escuela Técnica Superior de Arquitectura de Valenci and civil engineering at the Swiss Federal Institute of Technology in Zurich. In 1981, Calatrava opened an architecture and engineering office in Zurich.

As a sculptor, architect, and engineer, Calatrava easily identifies with each discipline. His engineering skills allow him to explore sculptural designs with unusual spaces, and his creativity and innovation in the designs of bridges and buildings have elevated him to superarchitect stature. In some circles he is considered a genius for his dynamic structures' transcendence of the traditional boundaries between art and architecture.

Calatrava's first built project in the United States was an addition to the Milwaukee Art Museum. Celebrated as a breakthrough in design, it consists of a kinetic structure that opens and closes, evoking wings. The design is so pivotal to Milwaukee's civic sense of self that the city government requested all the pieces of design process that they could get, including several prototypes that were converted into working phone booths along Lake Michigan. The structures' wings serve as signage, indicating whether the booth is occupied. When the booth is vacant, the flaps close together. As a side note, there have been sightings of a caped man in a blue suit using the booths—Calatrava may be taking this superarchitect thing a bit too literally.

BIBLIOGRAPHY

Frampton, Kenneth. *Modern Architecture: A Critical History.* London: Thames and Hudson, 1980, 1985.

Hyman, Isabelle, and Marvin Trachtenburg. *Architecture: From Pre-History to Post-Modernism.* New York: Harry N. Abrams B.V., 1986.

Raeburn, Michael. *Architecture of the Western World.* London: Orbis Publishing Limited, 1980.

Sharp, Dennis. *The Illustrated Encyclopedia of Architects and Architecture.* New York: Quatro, 1991.

Turner, Jane (ed.). *The Grove Dictionary of Art.* New York: Grove's Dictionaries, Inc., 1996.

Whiffen, Marcus, and Frederick Koeper. *American Architecture,* vols. 1 and 2. Cambridge: Massachusetts Institute of Technology, 1981.

www.ancientegypt.co.uk/life/home.html, © The British Museum.

www.archinform.net, © archINFORM, 1994–2003.

www.columbia.edu/cu/cup/cee/cee.html, *The Columbia Electronic Encyclopedia,* Columbia University Press, 1994, 2000.

www.eliel-saarinen.com.

www.famousamericans.net/thomasustickwalter/, © Virtualology, 2000.

www.godalming-museum.org.uk/jekyll_and_lutyens.html#SIR%20EDWIN%20LUTYENS, © Trustees of Godalming Museum, 1998.

www.lutyens-furniture.com/sir_e_lutyens.html, © Candia Lutyens.

www.newadvent.org/cathen/, The Catholic Encyclopedia, 1908, © K. Knight, 2003.

www.open2.net/modernity/archindex.htm.

www.prairiestyles.com/wright.htm, © Prairie Styles, 1999–2003.

www.pritzkerprize.com, © The Hyatt Foundation, 1999.

www.telephonetribute.com, © David Massey, 1997–2003, Ron Christianson, 2003.

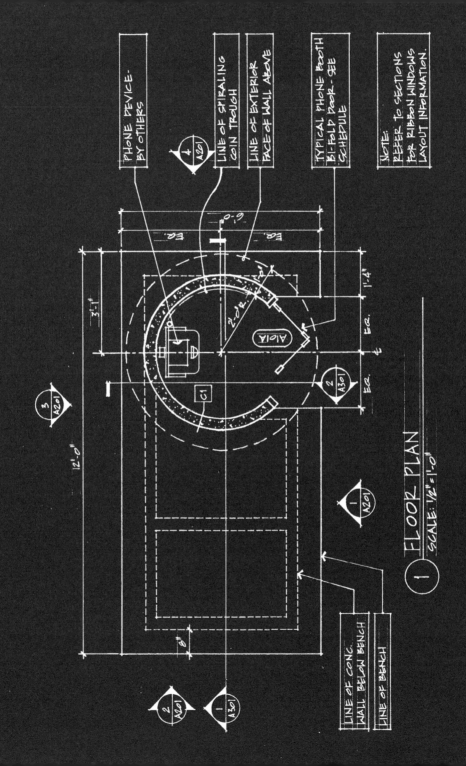

PHONE DEVICE- BY OTHERS

LINE OF SPIRALING COIN TROUGH

LINE OF EXTERIOR FACE OF WALL ABOVE

TYPICAL PHONE BOOTH BI-FOLD DOOR - SEE SCHEDULE

NOTE:
REFER TO SECTIONS FOR RIBBON WINDOWS LAYOUT INFORMATION.

4 / A201

3 / A201

2 / A201

1 / A201

2 / A201

1 / A301

A101A

C1

FLOOR PLAN
SCALE: 1/2" = 1'-0"

1

12'-0"

3'-1"

6'-0"

8"

1'-4"

E.Q.

E.Q.

E.Q.

E.Q.

E.Q.

LINE OF CONC. WALL BELOW BENCH

LINE OF BENCH